Dan Weiner

There have always been a few serious,
gifted hands working in photography since its beginnings.
Dan Weiner was one of them. His qualities were: an amazing
competence; faithfulness to himself; solidity of heart in his
work; and a sound, professionally dependable talent that
gave off a steady glow. The glow came from the humanity of
the man, maintained in the teeth of the usual strain and in-
roads in the lives of idealistic workers in any difficult field.

From "Dan Weiner," by Walker Evans, *Print*, vol. XIII: 2 (March–April, 1959).

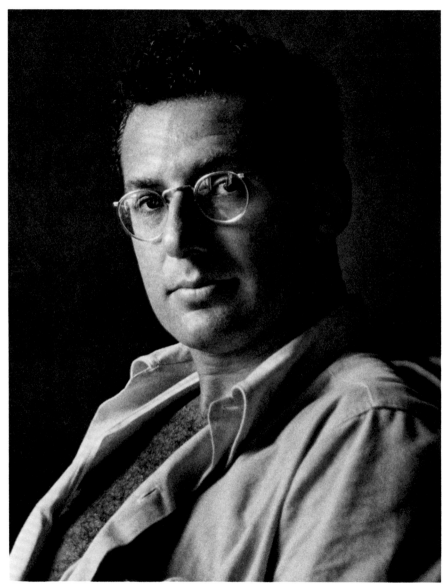

Dan Weiner, 1950
by Sandra Weiner

Dan Weiner

1919–1959

GROSSMAN PUBLISHERS
A Division of The Viking Press
New York 1974

ICP LIBRARY OF PHOTOGRAPHERS

Series Editor
CORNELL CAPA

Series Associate Editor
BHUPENDRA KARIA

ICP—the International Fund for Concerned Photography, Inc.—is a nonprofit educational organization. Established in 1966 in memory of Werner Bischof, Robert Capa, and David Seymour—"Chim"—ICP seeks to encourage and assist photographers of all ages and nationalities who are vitally concerned with their world and times. It aims not only to find and help new talent but also to uncover and preserve forgotten archives, and to present such work to the public. Address: 275 Fifth Avenue, New York, N.Y. 10016.

VOL. 5: DAN WEINER

Editors
CORNELL CAPA
SANDRA WEINER

Editorial Consultants
YVONNE KALMUS
ROBERT SAGALYN
DONALD UNDERWOOD

Research Assistant
LAURIE SAGALYN

Design
ARNOLD SKOLNICK

ACKNOWLEDGMENTS
Our appreciation and thanks to Walker Evans, Leo Lionni, Russell Lynes, Arthur Miller, Alan Paton, and Nicolai Tucci for their kind permission to reproduce their writings.

All unattributed text is by Dan Weiner.

Contents

For me the camera has the ability to distill significant fragments from the complexities of everyday life. The ability to make coherent, to simplify from the mass of details. Photography today should speak with urgency, should be free from contrivance, so that it must never be suspect. I strive for intelligibility because photography as communication to me is its noblest calling. The area of photographing human relations is not new but rather a development from Lewis Hine and the Farm Security Administration. The thread of humanism has greater vitality than ever, even if abused today. Photography combines those elements of spontaneity and immediacy that say "this is happening, this is real," and creates an image through a curious alchemy that will live and grow and become more meaningful in a historical perspective.

—Dan Weiner

My first photographic attempts were made with a 9 x 12cm camera which I perched on top of a heavy wooden tripod. The results of that period were technically very satisfying, and I still owe a debt of gratitude to that old 9 x 12.

My first glimmerings of unrest came while composing carefully in the ground glass, watching bits of life pass by and become petrified before I could remove the ground glass and insert the film pack adapter. If I attempted to recapture the initial vision by reenaction, it always seemed very contrived. This led to dissatisfaction with the static quality and a sense that I was not coping with today's tempo. For me, it meant a process of simplifying the photographic procedure to its barest essentials. The paraphernalia of technique obviously had to be eliminated to the point where there would be no barriers between the initial vision and the logical, clean solution through the camera. The photographer and the camera had to be made as unobtrusive as possible so that his personality would not intrude or the consciousness of the camera not change the natural course of events. Respect for reality must be the basis.

The 35mm camera is the most refined tool available at the moment for this particular kind of seeing. It allows the photographer flexibility of selecting any one of thousands of possible frames within a space of a few minutes. It is a way of making statements about things in a personal way through the use of split seconds.

Photography is very easy; at the same time it has remained one of the most difficult mediums in the world. It has reached a point where it is highly regarded as a communicator—a sort of visual educator. But I think we must also try to achieve a quality that goes beyond the moment and wherein lies another dimension, another aspect of photojournalism. This, I think, is the logical end to strive for: elevating photojournalism to the point where it will have more than just a momentary shock value, but will create visual images that are long remembered and have continued meaning. We haven't scratched the surface yet of the possibilities of the medium of photography, to use this tool as a universal language to bridge the gaps between people.

The Camera to Me
Dan Weiner

The quality of art is the images that will stay and grow and develop with time. I have found that my imagination has paled before the incredible richness and complexities of life.

I have tried in my work to carry forward the best aspects from the documentary tradition. I feel it to be the job of the documentary photographer to probe much deeper beneath the surface. No longer can the documentary worker make do with the few obvious symbols in his little bag. Now comes the challenge of making photography as flexible as life itself. Certainly the tools are here.

The artist who works from the inside—who deals with the ideas and forms and symbols of his life experiences—develops an inner vision. The constant brief scrutiny of unfamiliar things can become very superficial commentary.

The problem of the survival of the creative spirit is not peculiar to the photographer alone. Long ago I came to recognize an innate creativity in all people—a desire for self-expression, to be considered a whole and individual person. It was much later and after much experience that I discovered that continued survival as a creative person against the crushing pressures, both personal and social— to be reasonable, to be practical, to belong—took more than just talent. It took great belief and dedication and necessity to continuously thread one's way through all the pitfalls in a society that is against the reliable and the steady.

There are certain things that I like to photograph and want to photograph and think are important. Naturally I do them. I'm interested in finding out how people live and how they adjust to the whole question of urbanization and industrialization and the by-products in their lives. These are the photographs I feel I must do.

This article is taken from various writings by Dan Weiner during the years 1951–1959.

On
Dan
Weiner

The very direct and sparse means
with which dirty and real and crumpled and moving things and people are elevated to the level
of universal symbols without sacrifice to their
identity, and without immediately calling to mind
the new clichés of the new academies, point to
areas of thought which concern all the arts.

Weiner never reports
the accident—man, thing, or event—as such.
It's always selected, isolated, and recorded as a
symbol and presented as a problem, a human
problem involving at least two persons—one of
whom is you. That is why his photographs are
always a moving experience.

It's good to find
that in the midst of increasingly frigid photographs of surface explorations (akin to abstract
and nonobjective painting), where the wall of a
slum becomes an esthetic rather than a social
condition, Weiner's pictures of human reality
have been growing in communicative force, importance of meaning, emotional impact—and
in beauty.

From Leo Lionni's introduction to Dan Weiner exhibition
at New York Camera Club, 1953.

New York City

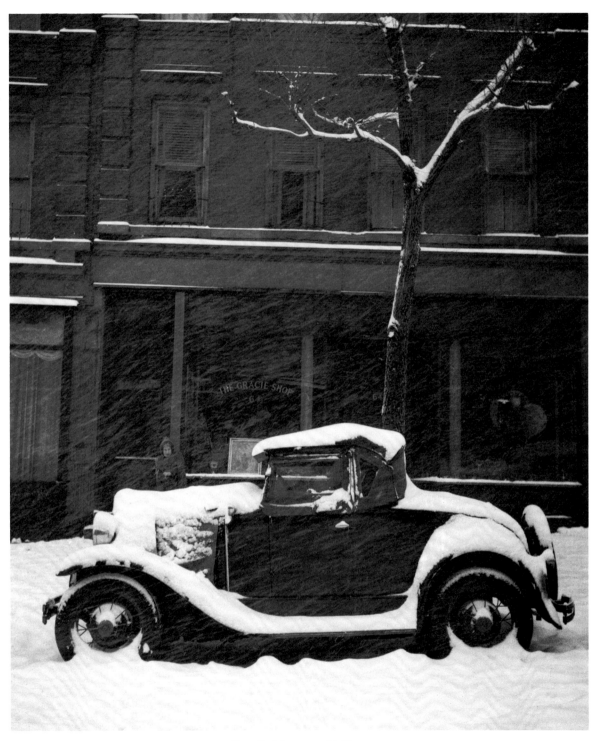

East End Avenue, 1949

A couple of years ago Dan and I were driving over a long causeway in Brooklyn which sweeps down along the Bay. On the right, below, were the South Brooklyn rooftops and the pigeon coops, straight ahead in the windshield was the Manhattan skyline on the other side of the river. The sun was burning in all the windows, the buildings looking like blinded men with orange eyes. "There's a picture for you to take," I said to Dan. He laughed and politely but firmly corrected me. "There's no people there. I'm not interested in scenery." I said that it had meaning anyway, lower New York, Wall Street blinded by the sun and yet strangely heroic, maybe like a god burning and aghast. He wouldn't waste a shot on it even when I offered to stop the car. "Those kind of pictures don't need me," he said, "I want to get people in some kind of relationship to meaning." We went on and into the tunnel without the picture.

He seemed to have no conflict—at least at the time of his life when I knew him, and it was, as it turned out, his last few years in the world—no conflict about photography being an art or not an art. I have never been all that sure about the question, but I sensed that when he raised the camera to his eye there was a certain holding of the breath for him, a fending-off of accident, which expressed his conviction that this was a deeply creative art. In short, his refusal to take the skyline was based on a principle of his art, and probably his politics and his moral ideas.

The longer I knew him and the more of his work I got to see, the younger he seemed to become. After his death I wondered about that, and I think it was partly because I had misjudged him and partly because he had two ways of behaving. I suppose a photographer had to do a certain amount of babying: he has to tune up his subject, bring him out of himself, especially if the subject is diffident about posing. So that a certain psychological *realpolitik* is part of his makeup or he can't operate. I may be all wrong, but most of the photographers I have spent any time with have become, willy-nilly, more cynic than photographer, gradually losing a basic human respect for those they have to cajole. Dan knew all the tricks, and they were old men's tricks, so to speak, and in the beginning I was naturally suspicious of his esthetic pretensions. But it gradually became clear that underneath he was very much of a child, the way an artist must always be until he is finished, a child who is fanatically pursuing the complicated toy of beauty. Perhaps that is the reason I literally found it impossible to believe it when I heard he had died. He was younger than he had ever been, to me. I think he was the only man I have known over any period of time who

got more and more instead of less and less impressed by the wonderful richness of existence. The death of such a phenomenon is inadmissible; it is inadmissible on principle, and one never really learns how to accept it but only how to pretend it did not really happen while knowing at the same time that it did. When the best of his work is displayed I hope it will reveal not only the man's deep seriousness but his child-like wonder and his quick laughter—in a word, his eager delight in the business of the planet.

From *Infinity*, vol. VIII:5 (May 1959)

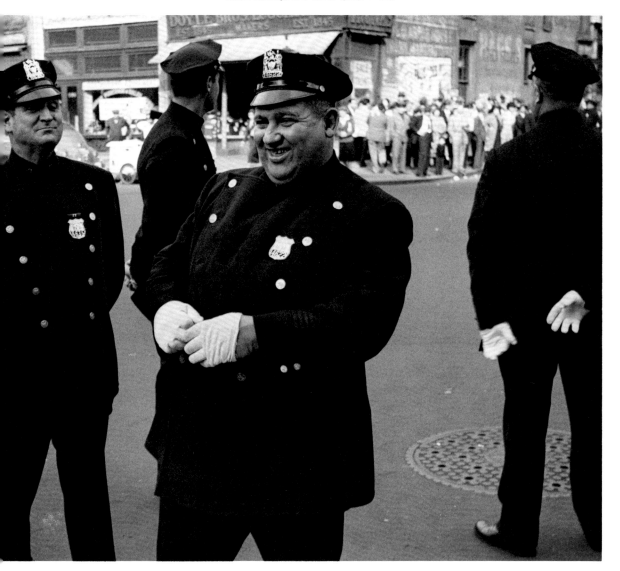

May Day, 1948

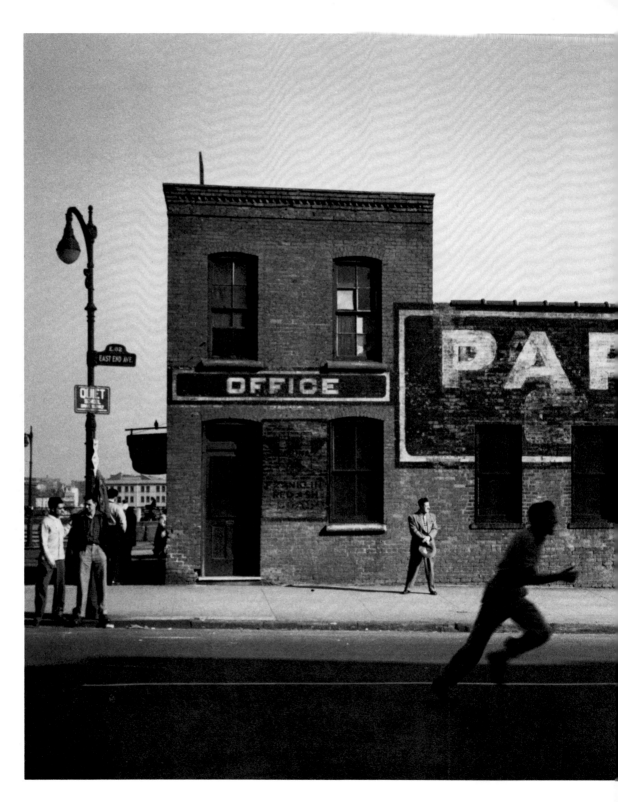

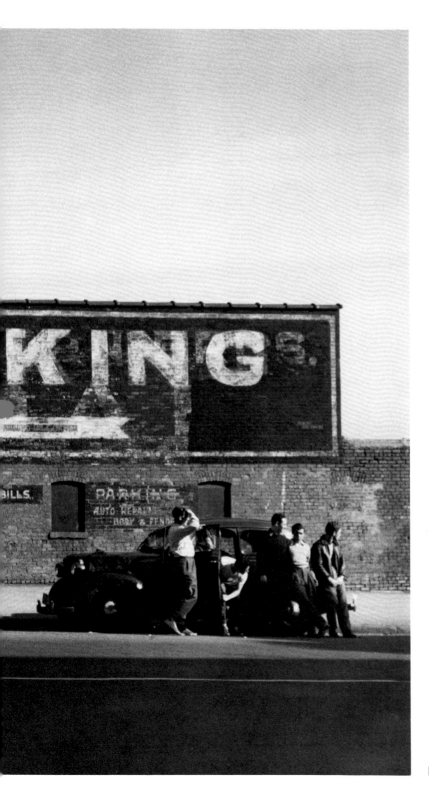

East End Avenue, 1950

13

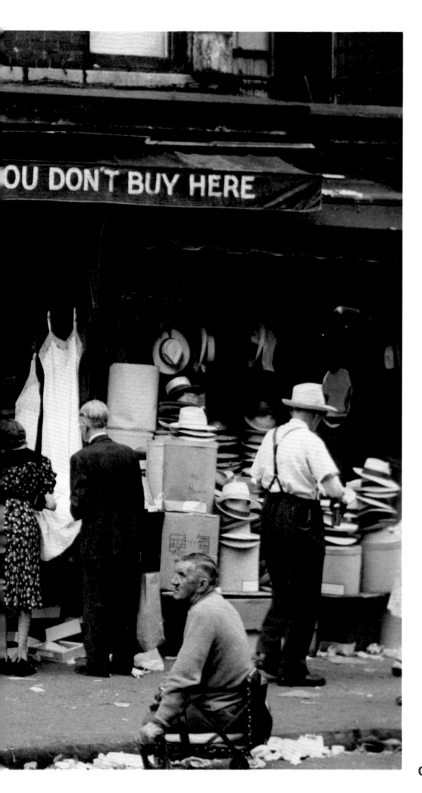

Orchard Street, 1948

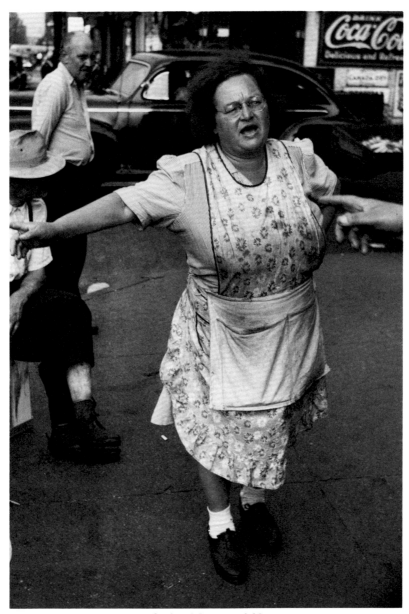

Orchard Street, 1948

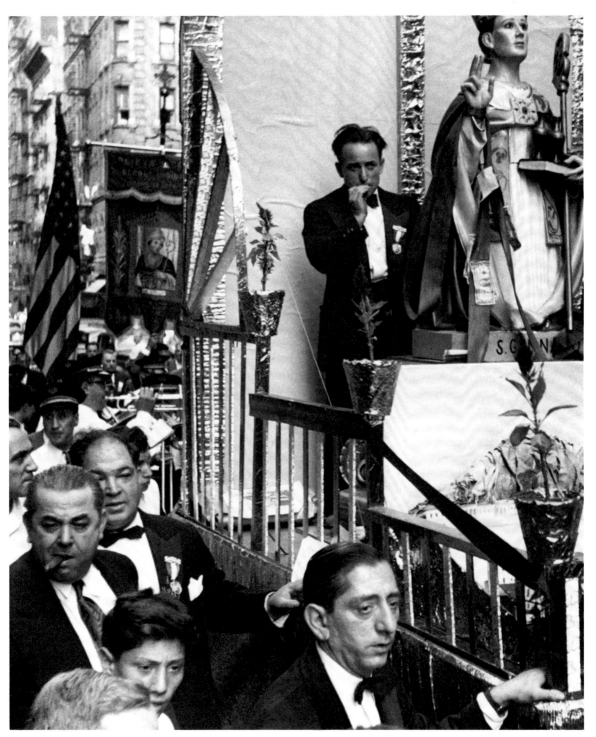

San Gennaro Festival, 1952

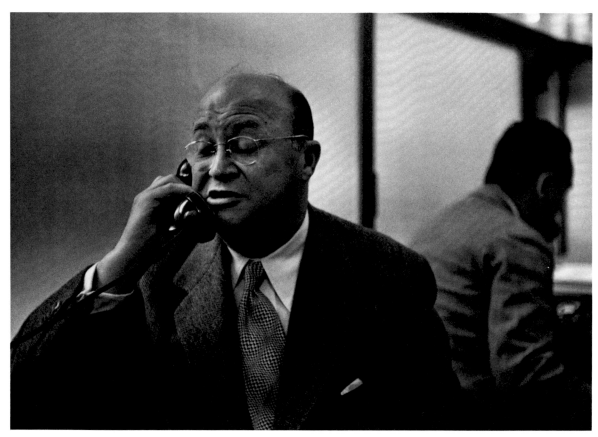

Burlington Mills, 1950

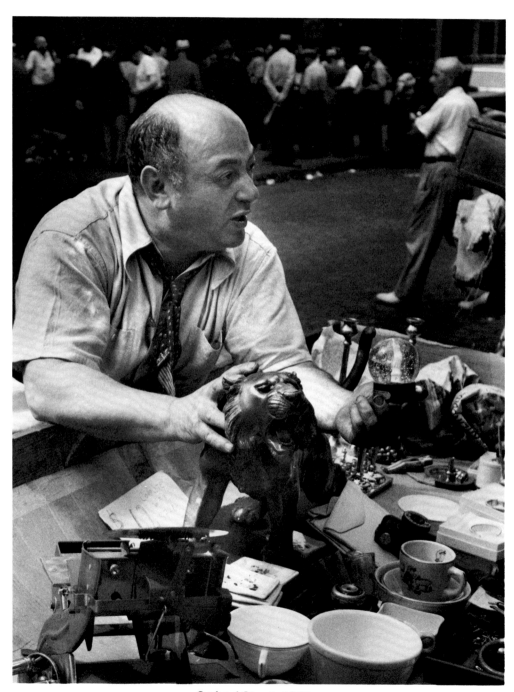

Orchard Street, 1948

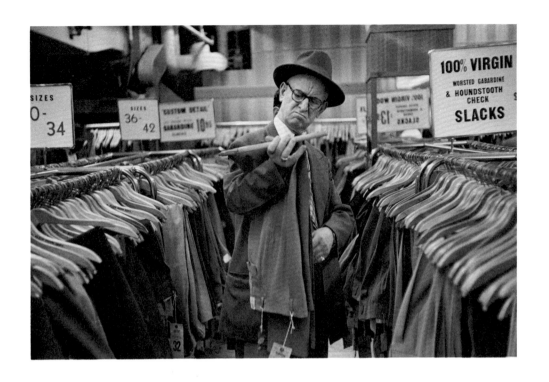

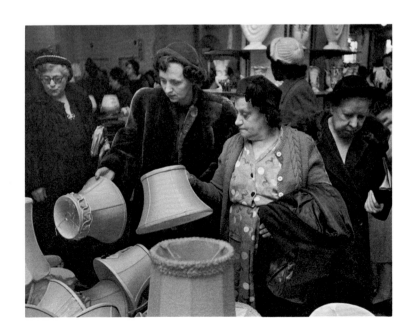

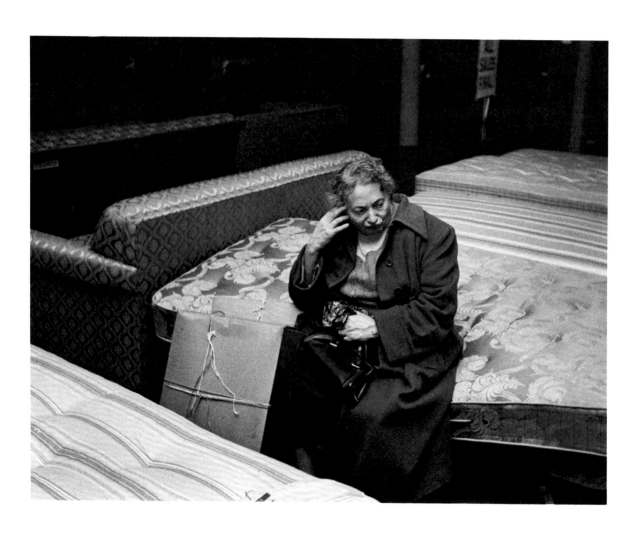

Brooklyn, 1956

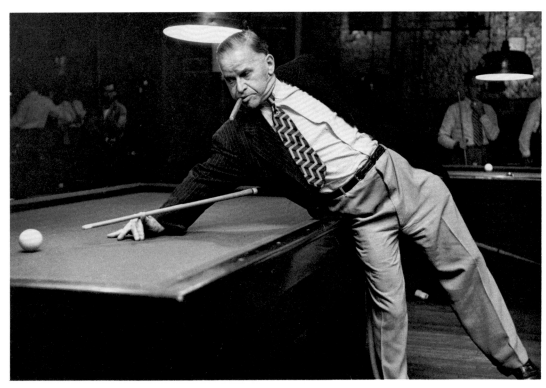

Poolroom player, 1955

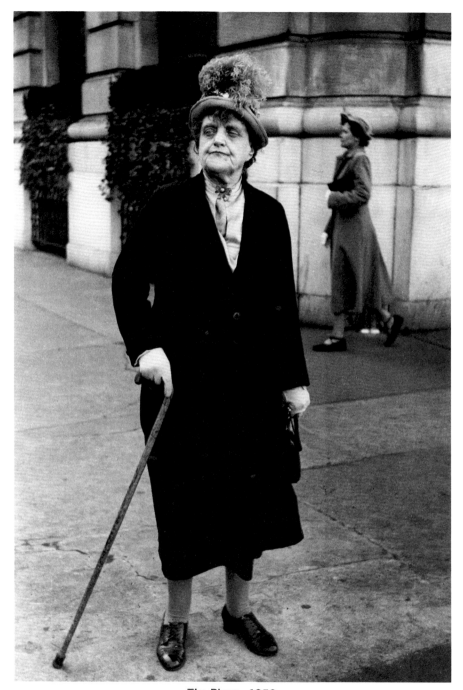

The Plaza, 1950

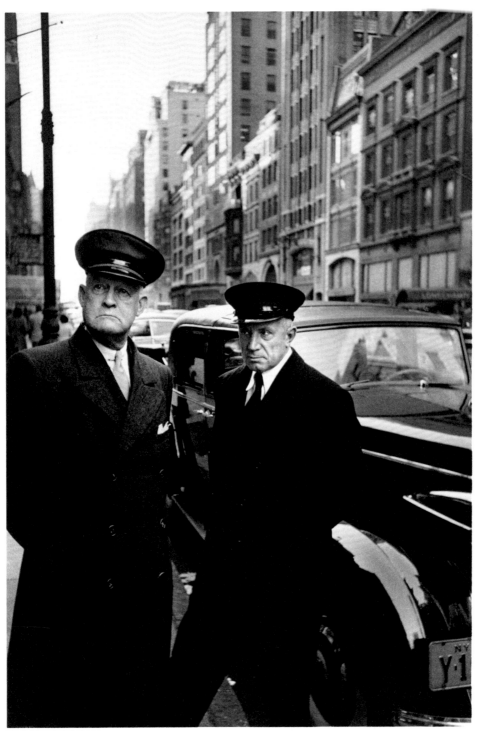

Chauffeurs, The Plaza, 1950

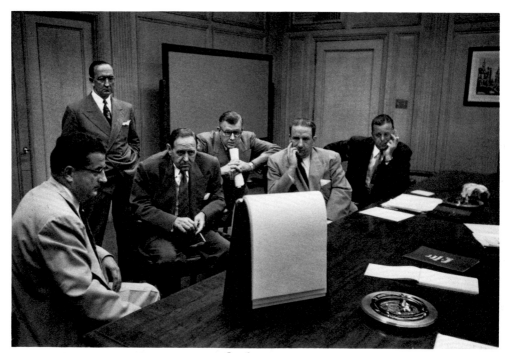

Conference,
Packard Motor Company, 1952

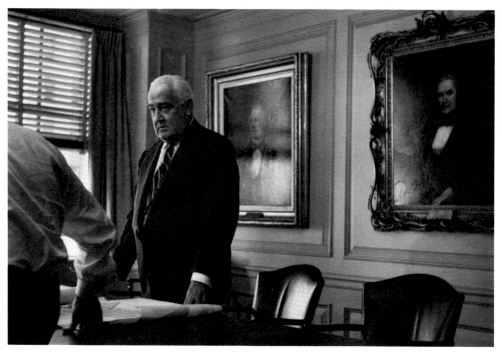

Anaconda Copper, 1949

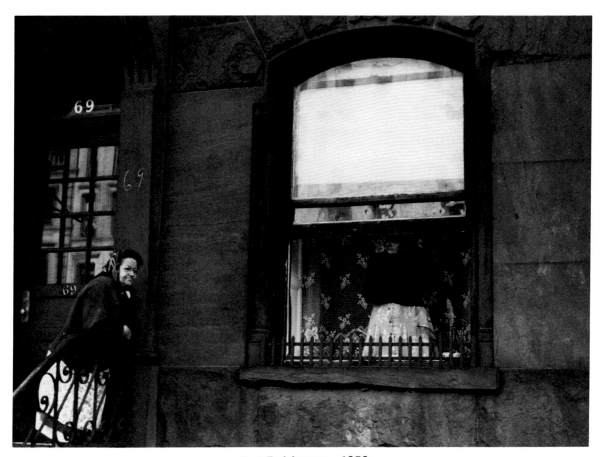

East End Avenue, 1950

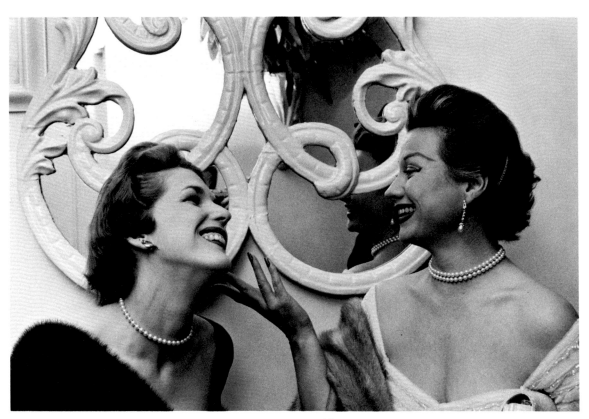

El Morocco, 1955

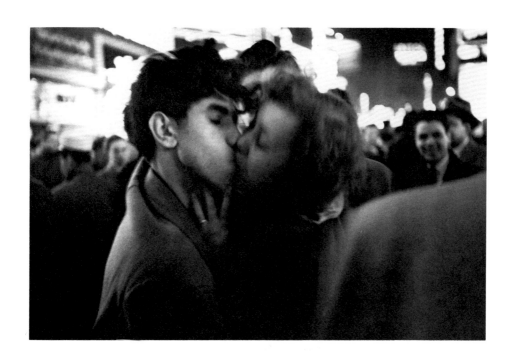

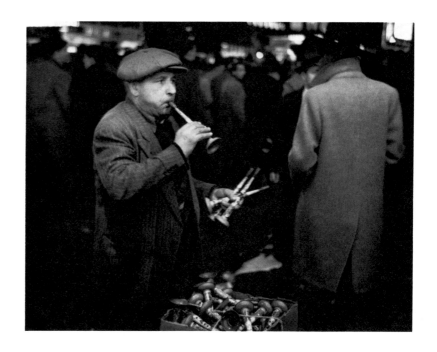

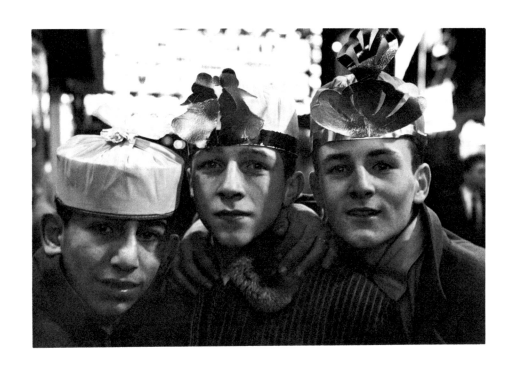

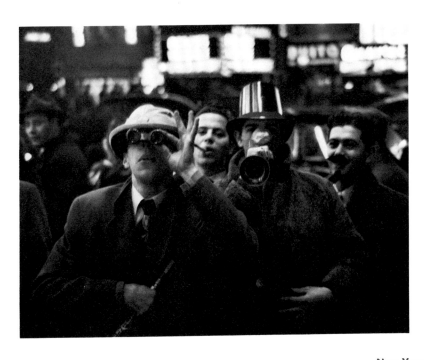

New Year's Eve, Times Square, 1951

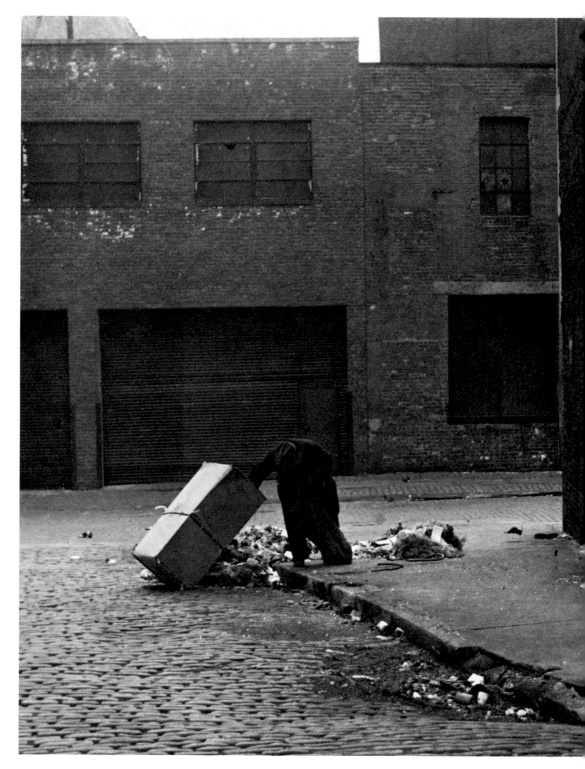

Lower East Side, 1949

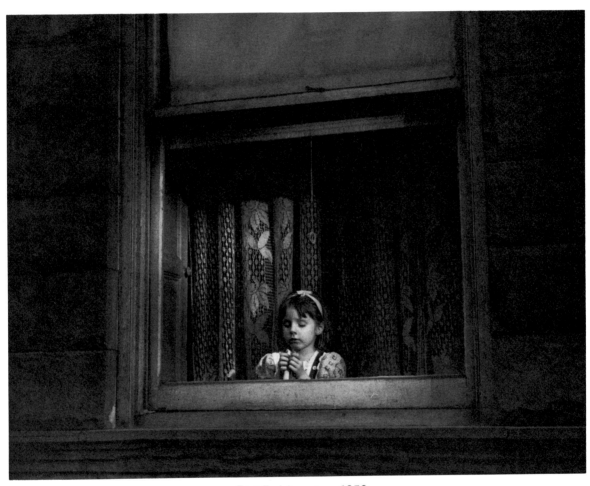

East End Avenue, 1950

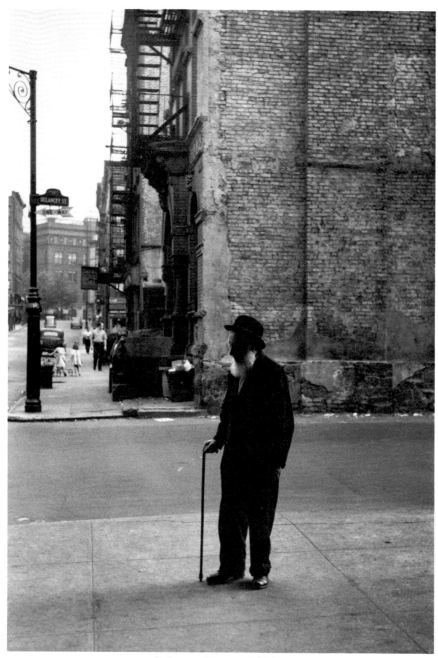

Delancey Street, 1949

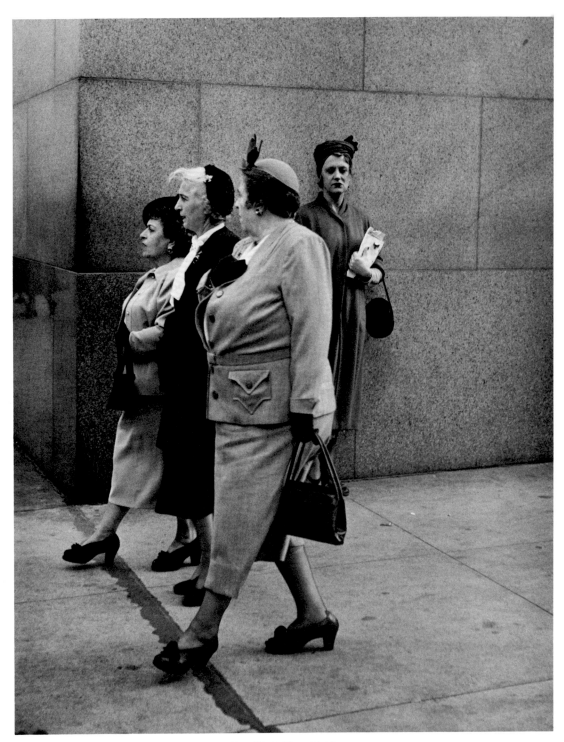

New York City, 1950

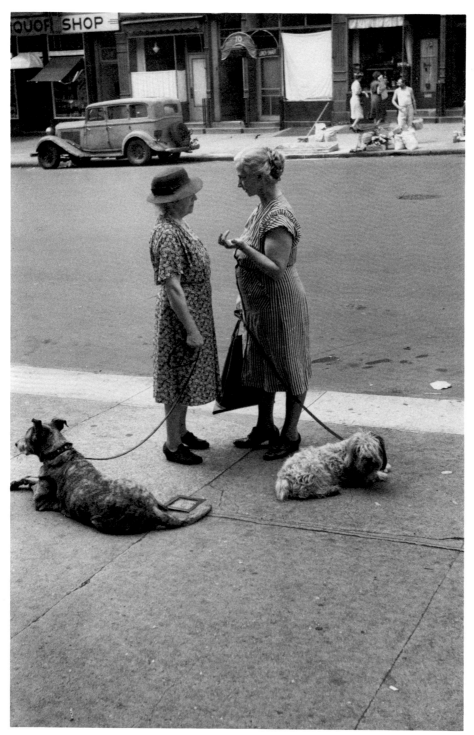

East End Avenue, 1950

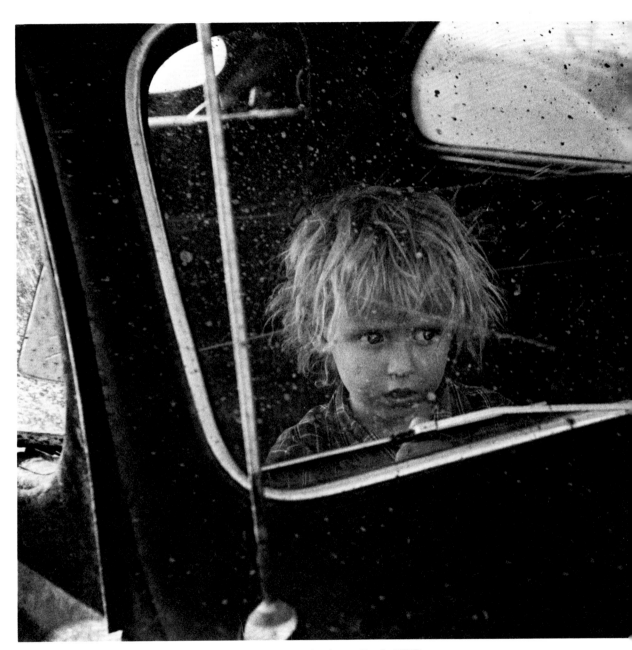

Mondamin, Iowa, flood, 1952

Mine is the first generation that can say that our understanding of the world and concepts of the forces and direction of society have been shaped not through the literary or the auditory, but the visual. Those of us who matured in the thirties felt the full impact of the newly developed visual media: the picture magazine and newspaper, the newsreel, the documentary still photograph and film. All of these provided a communication and a sense of shape to the social and economic problems of the day. The breadlines, the dust bowls, the rise of Hitler became sharp realities for me, more through the photograph than the printed word. This has produced a generation of photographers like myself whose restless lens keeps probing at the central issues of our day and who have pushed the photographic horizons farther and deeper into the shape of the world and men's relation to one another.

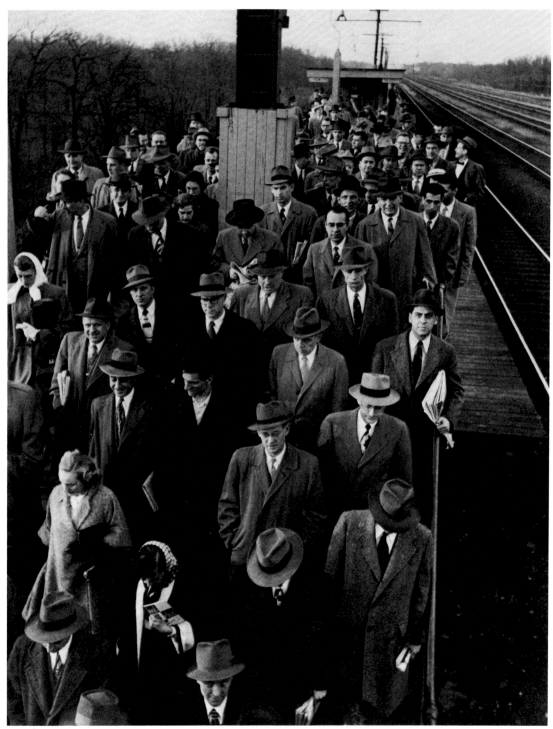

Commuters,
Forest Park, Illinois, 1954

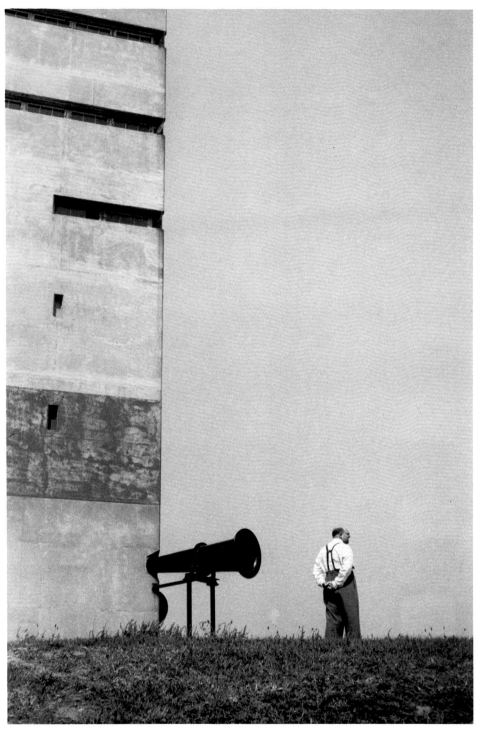

Montauk Point, Long Island,
New York, 1949

After the flood, Mondamin, Iowa, 1952

Hudson,
New York, 1952

Washington, D.C., 1955

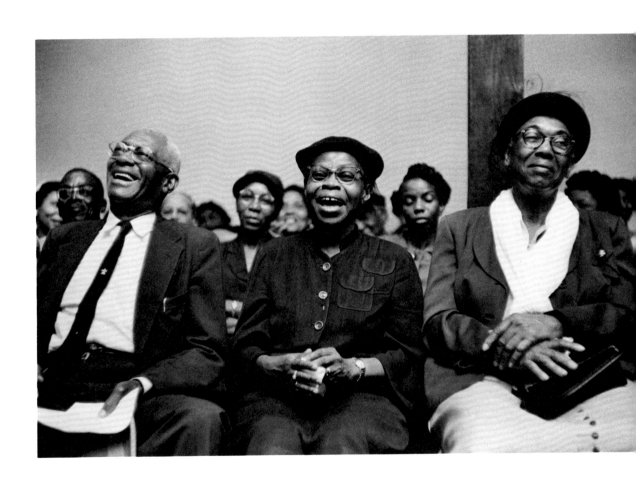

I would say that the question of Montgomery, Alabama, was well covered in some of the press. In particular, I recall, *Life* did an excellent week-by-week coverage.

The attitude at *Collier's*, for whom I was doing the story, was no different from many other publications that use photographs. The photographer is used somewhat like a plumber: when they have a hole to fill, they rush him out. I could not help but feel that my Montgomery pictures, published along with some others in an article about the dilemma of the moderate in the South, were used to illustrate something quite out of context.

There was a larger issue at stake. It was a question of a whole community suddenly rearing up on its hind legs and challenging the powers that be. There was a new Black in the South who was developing a new strategy of resistance to segregation with economic, legal, and spiritual weapons. I felt that photography had to look at the whole social scene more broadly and go into it more deeply. My point was to show the great forces struggling here in one area. I felt that this was an historic occasion which I must try to record with my camera.

While I was in Montgomery, I thought of something Alan Paton had said to me in 1954 when we traveled together on a story on the Negro in America. He said that: ". . . these people, through their struggles to achieve their basic rights as citizens, are reeducating us as to the meaning of true Americanism."

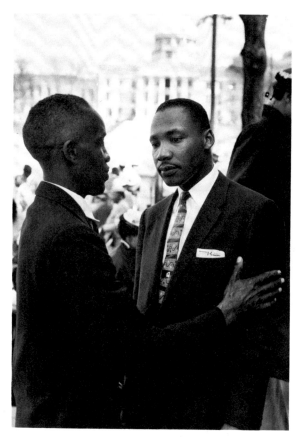

Reverend Martin Luther King, Jr.,
Montgomery, Alabama, 1956

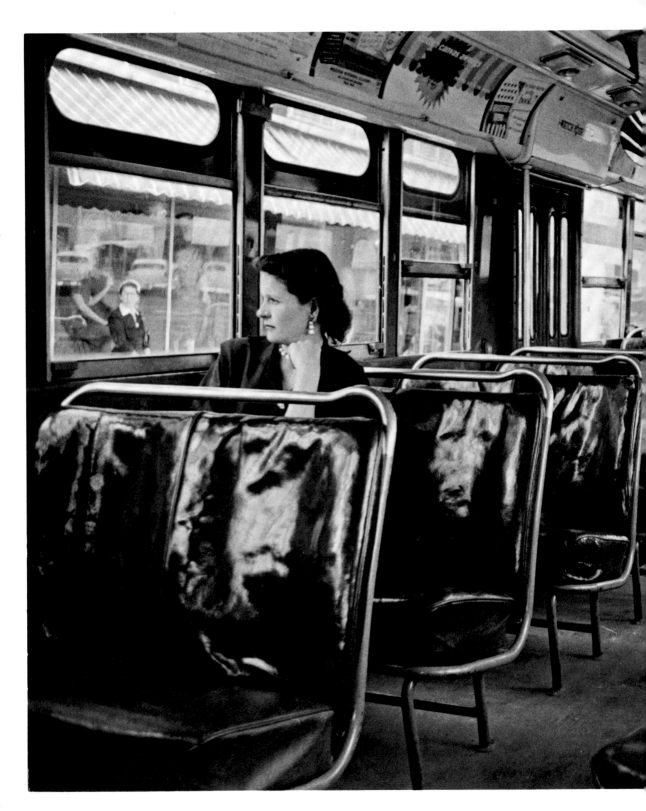

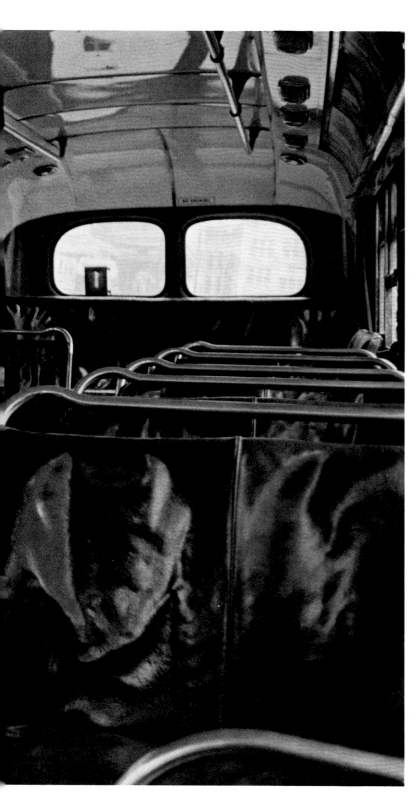

**Bus boycott,
Montgomery, Alabama, 1956**

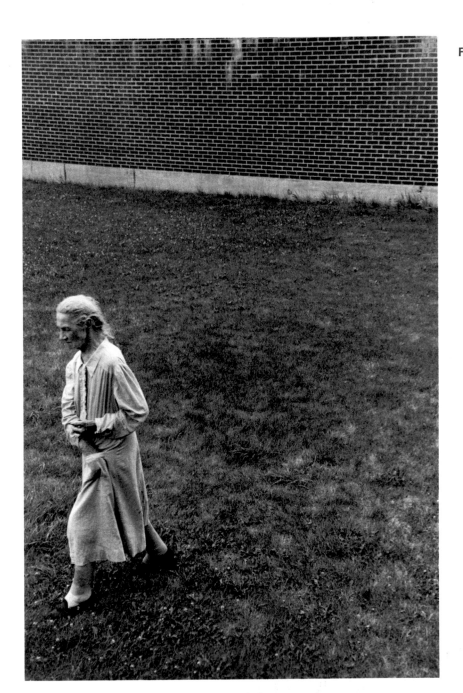

Old age home,
Fort Wayne, Indiana, 1950

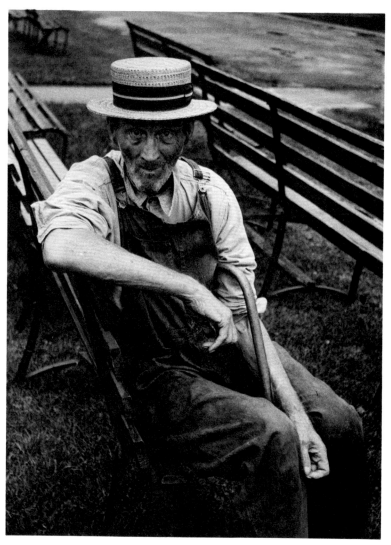

In 1949 I did an assignment
for *Collier's* of an old-age home in Fort Wayne,
Indiana, where twenty-nine people died of mal-
nutrition. It was a story that threw me into a
situation that I had never thought about much
before, and it shocked me. I decided to pursue
the subject and do a story that would highlight
this problem. I tried for many years and, in fact,
I did many photographs. When I tried to interest
some publications in running them, it was of no
avail. It may be treated well in text but the publi-
cations seem to shy away from the photographs
—the visuals are too disturbing, too revealing.

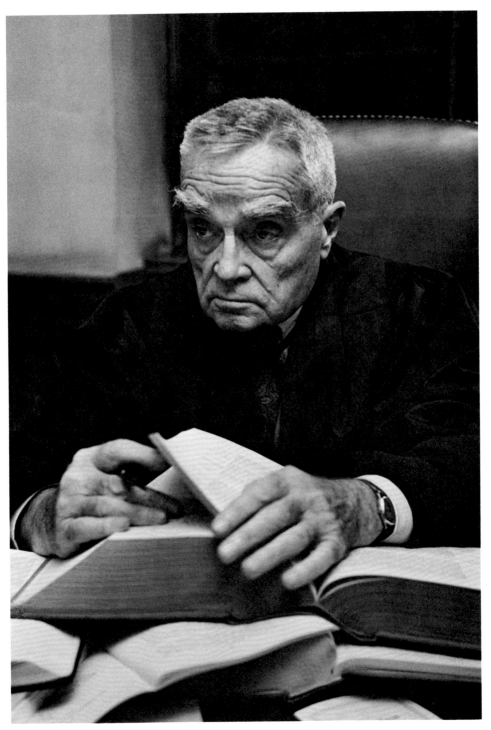

Judge Learned Hand, 1952

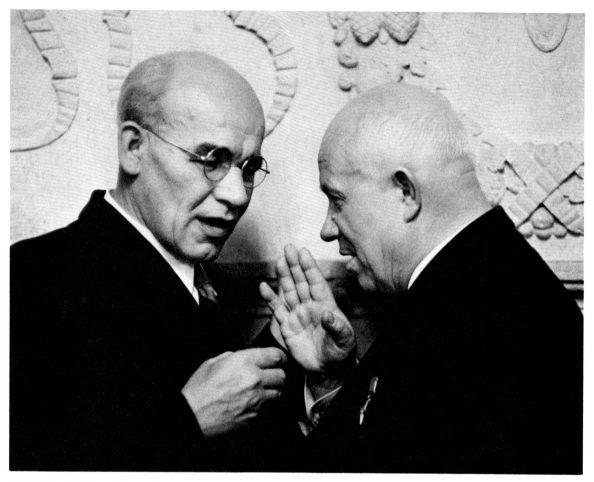

Polish Premier Gomulka and
Soviet Premier Khrushchev,
Moscow, 1957

So many influences make one a photographer and give one a sensitivity in any given area of society—so many qualities we don't think about as belonging to photography. I think that these are the things we learn as we go through life.

I've been extremely fortunate in so many of the photographic assignments I've had through the years. Through these assignments I've been introduced to areas of society, sections of the world, people that I never knew existed. This is what photography is made of: your relationship to yourself, to the people around you, what you feel, what you have to say, and then, how you see it.

Bruno Walter, 1958

Igor Stravinsky, 1956

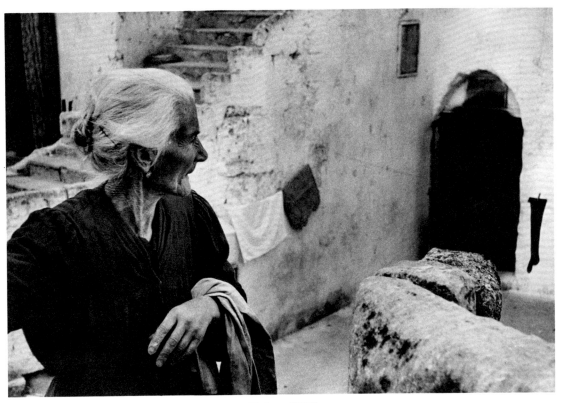

Matera, 1954

In the south of Italy lies a land that is barren and desolate, where the peasants live out their existence in poverty. Here one feels the hands of time stopped and the land is today what it has been for centuries, "the problem of the South." One such place is Matera, situated in the region of Lucania, where 15,000 people crowd into the caves of the *Sassi*, or Stones.

The streets of Matera are just one street winding around the hill town in a large spiral: in front of some houses and on top of others. Only the houses on the very top of the hill have a real roof all their own.

The peasants scratch at the harsh soil with their age-old implements and live in the same caves as did their ancestors, without water or the most primitive sanitation. Matera, always poverty-stricken and devastated by disease, has seen vast changes since the second great war.

The hieroglyphics stenciled on the walls in the *Sassi* say "DDT" and, more than any magic sign of old, they have wrought a powerful change in the land where it was once said Christ never came.

In the old peasants' stooped gait and stoicism is still the air of resignation to centuries of suffering. Death is always familiar in the mourning clothes worn by the women, whose dark shapes dominate a landscape of whitewashed brick and stone. But today there are many signs of a new life for Matera and the walls of the *Sassi* reverberate with the vitality of children no longer wasted with trachoma and malaria.

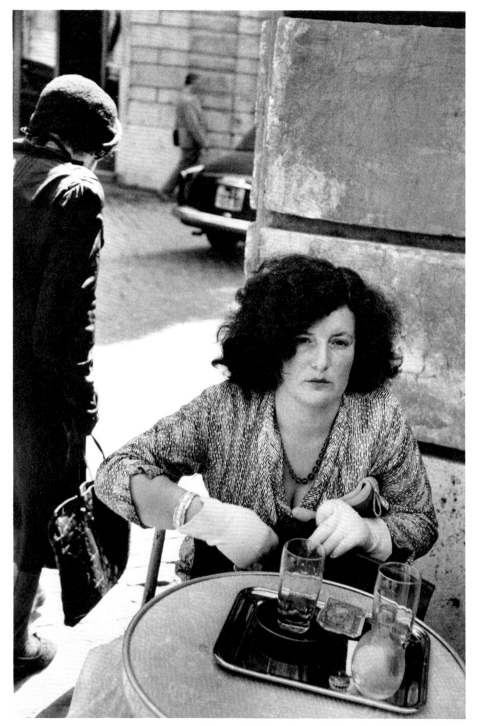

Rome, 1954

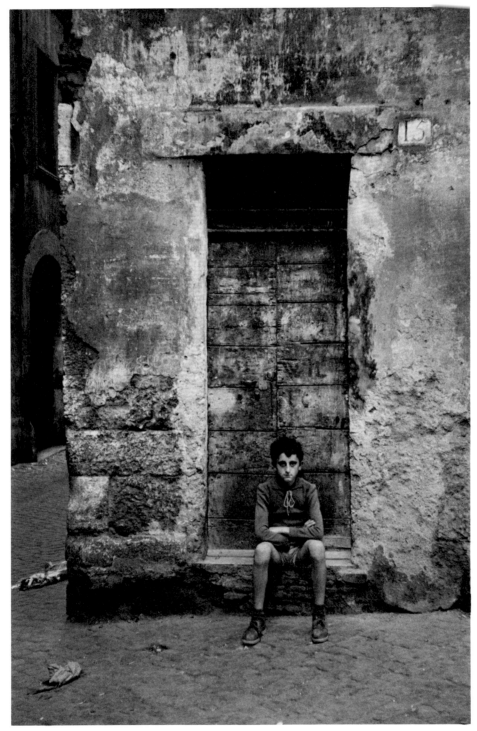

Rome, 1954

First communion is a great event in the life of a little girl, even in a big city. But infinitely more in a place like Matera where the two ceremonies —confirmation and first communion—usually take place in the same day. To wash, iron, fit, and wear a white dress and a white veil all day long is too much of an ordeal to be repeated on two different occasions. The little girl herself feels awe-stricken not only by the importance of the event but also by the monumental role she is supposed to play.

From Nicolai Tucci's introduction to Dan Weiner's "Communion in Matera," *ASMP Annual*, 1957.

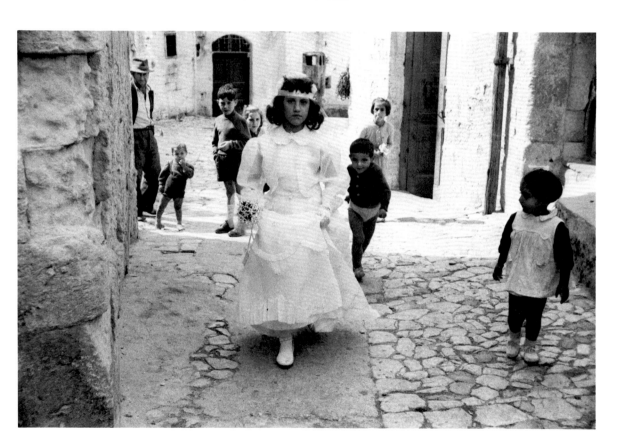

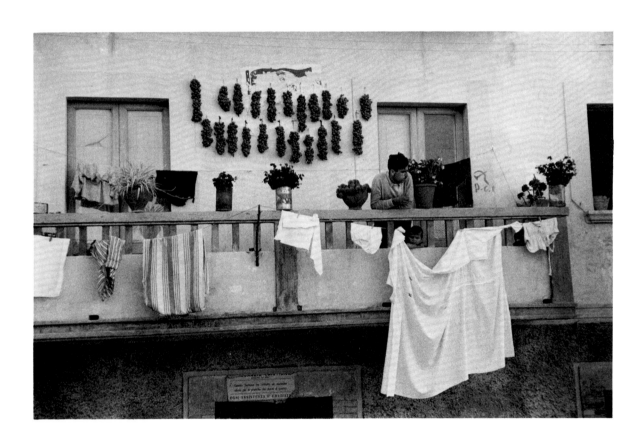

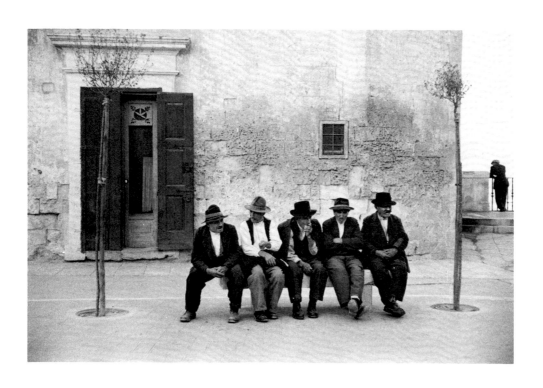

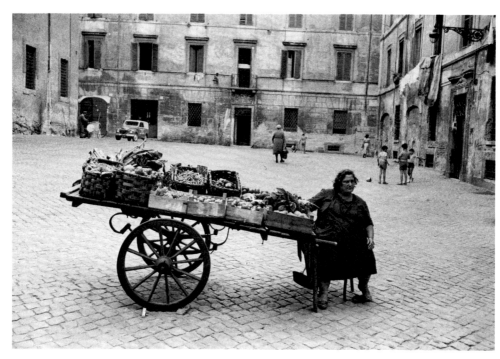

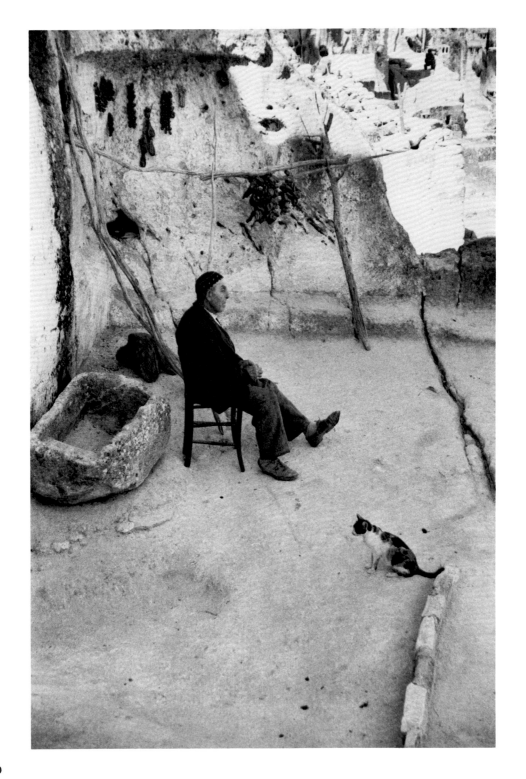

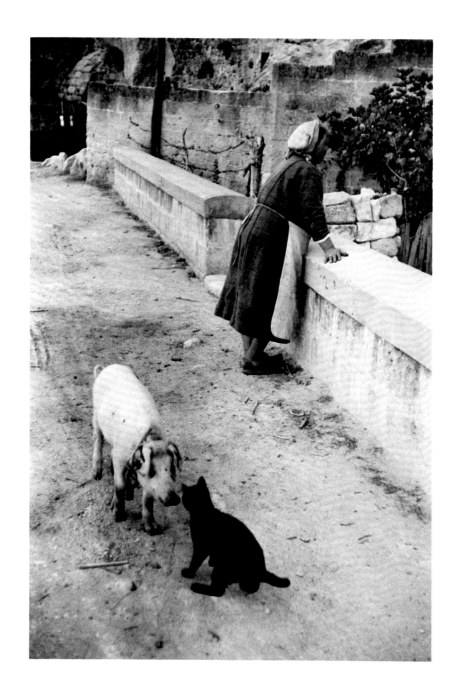

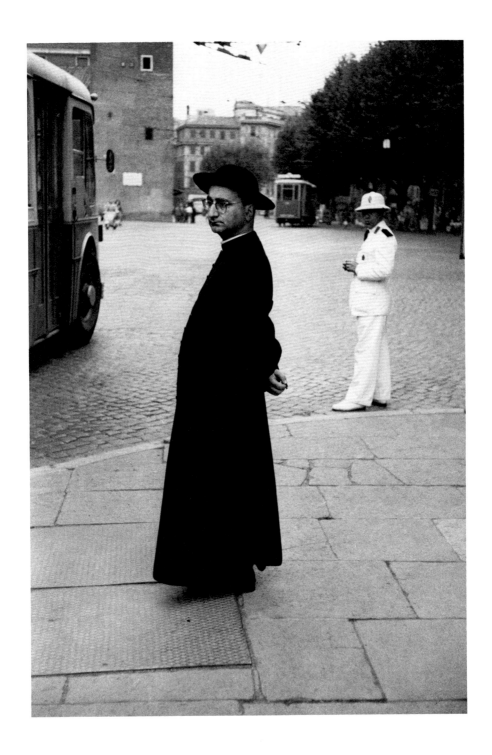

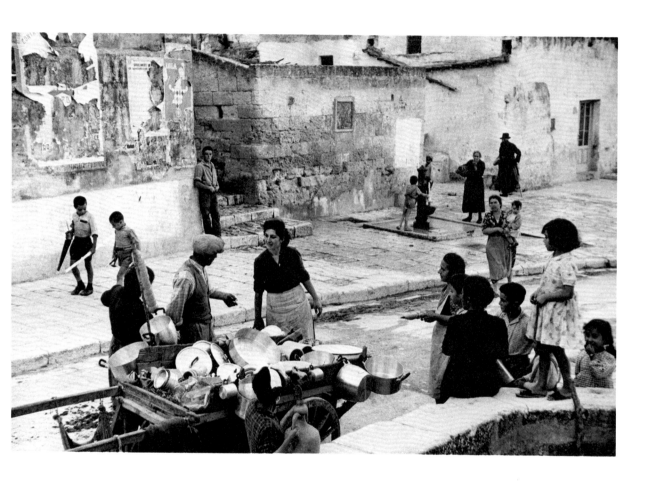

South Africa

Dan Weiner and I first met in New York in 1954 when *Collier's* commissioned us to do two articles on the Negro in America. We both had a love of art and literature and loathing of racism and we got on so well that we decided to do a book to be called *South Africa in Transition.*

The next year we met in Johannesburg, traveled via the famous Kruger Park Game Reserve and Swaziland to Durban, then through the famous human reserve known as the Transkei, over some of the majestic mountain passes of the Cape Province; then to Cape Town and back over the bleak and forbidding Karoo to Johannesburg.

I wanted to write the text of the book first so that he could take pictures to illustrate it. In the end I had to write a text to illustrate the pictures. I wanted to give a vast and varied physical setting of our racial problem: a great panorama of life and space, mountains and rivers, plains and desert. But Dan wilted in scenery; he wanted people—the incredible conglomeration of races and colors that makes South Africa. He liked people anywhere, but he liked them especially in cities.

He was a true photographer; he was brave, eager, took rebuffs in his stride, resisted authority when it became overweening, and went anywhere and everywhere if he thought he could get a picture.

Being a lover of mankind, he hated Senator Joseph McCarthy and the white supremacists of the deep South. Caustic about the shortcomings of his country, quick in her defense, he upheld the Constitution, backed the Supreme Court, hated the Faubuses, took pictures whenever and wherever possible. He was a fine human being—rough, warm, stubborn, devoted, and a true friend to me.

An unpublished eulogy, 1959.

Dan Weiner

Alan Paton

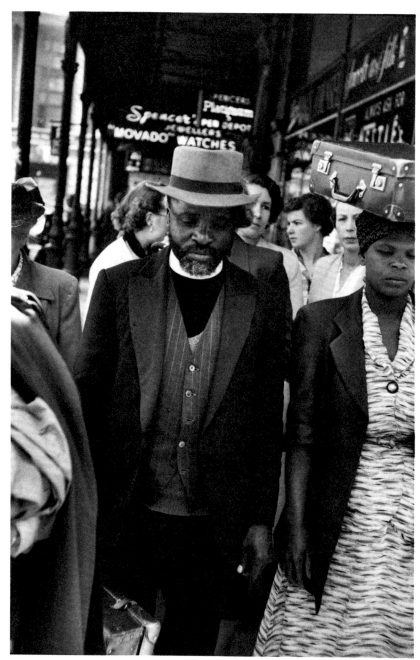

South Africa, 1954

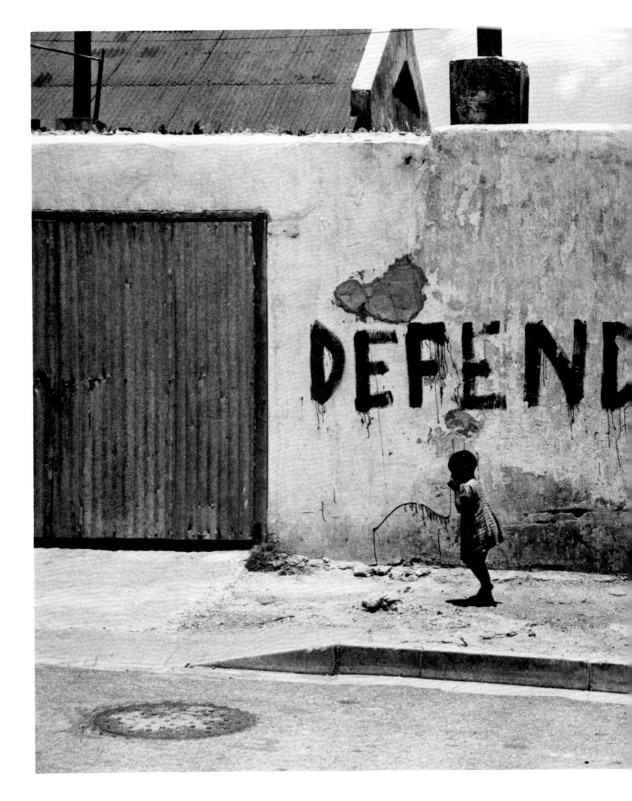

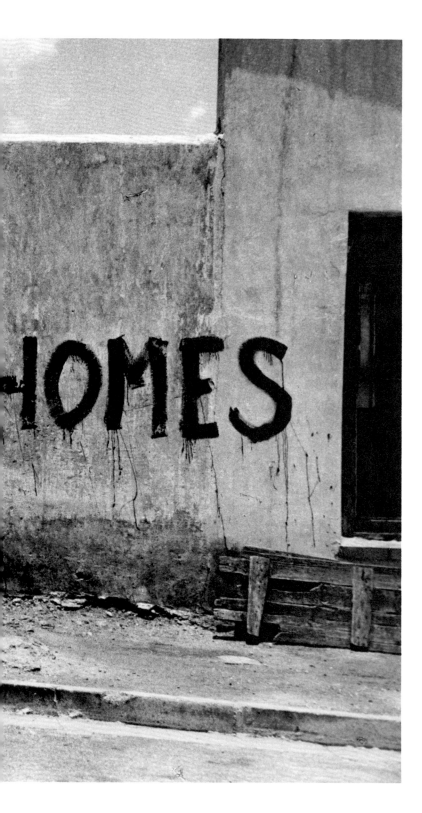

These photographs of South Africa represent the combined thinking of Alan Paton and myself. We covered over 4,000 miles of the country. We saw and photographed the native in his tribal areas on reservations. We followed him to the mines and factories, to the slums of cities. Everywhere was the marked visual anachronism of the compression of time—of thousands of years of history—from tribe to urban living, within a few short years. In the city streets, in the mine compounds, in the market places we saw this fantastic juxtaposition of dress and custom.

South Africa is fast becoming a modern industrial society and alongside Western civilization, African culture and tribal custom is withering away. Above all, this vigorous and developing people is being denied their democratic rights.

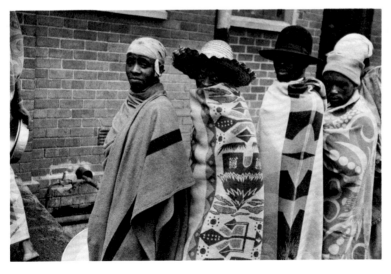

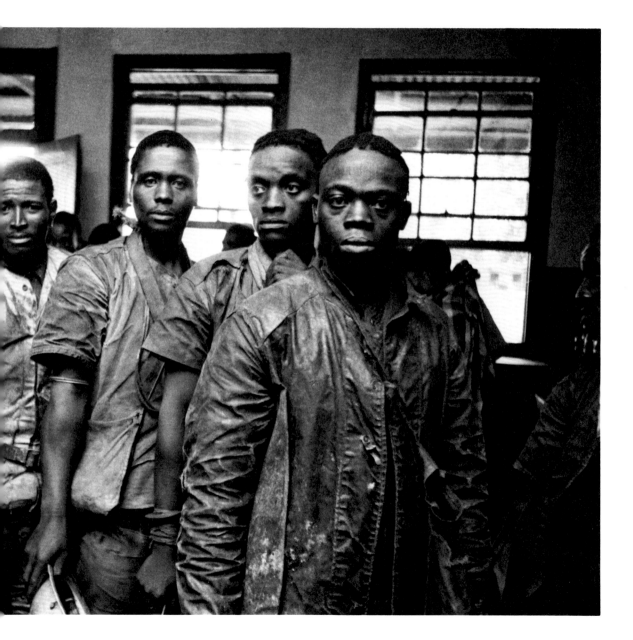

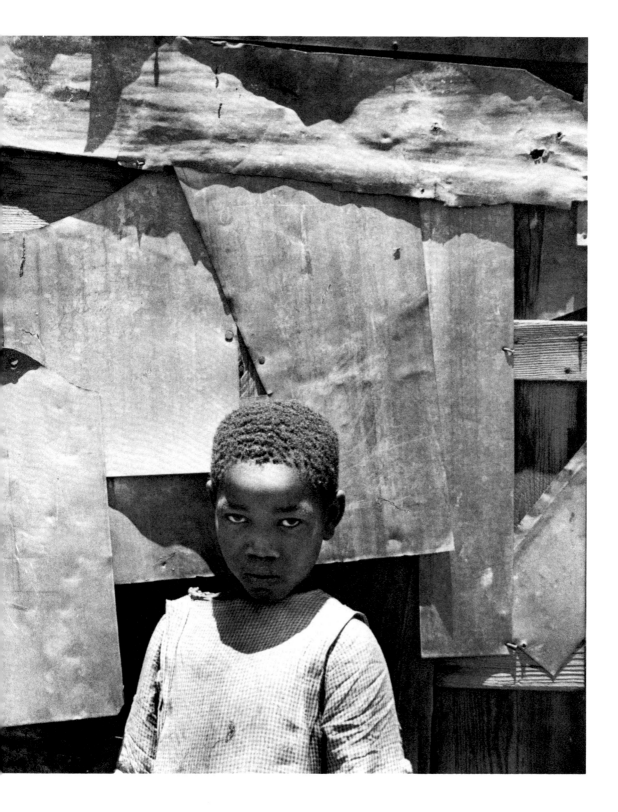

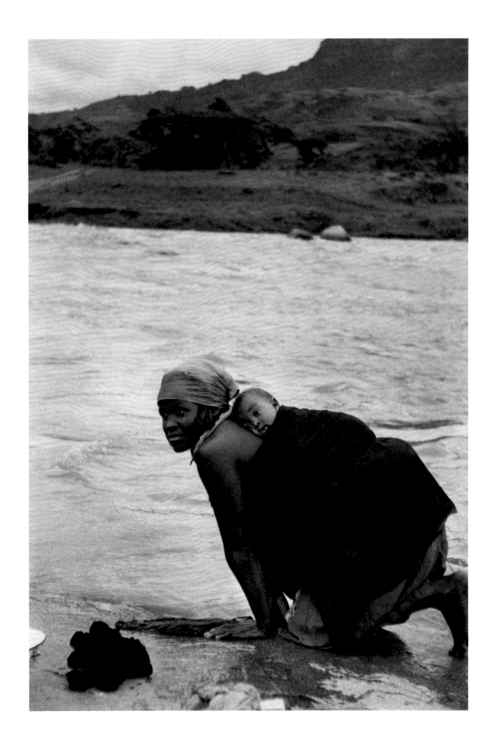

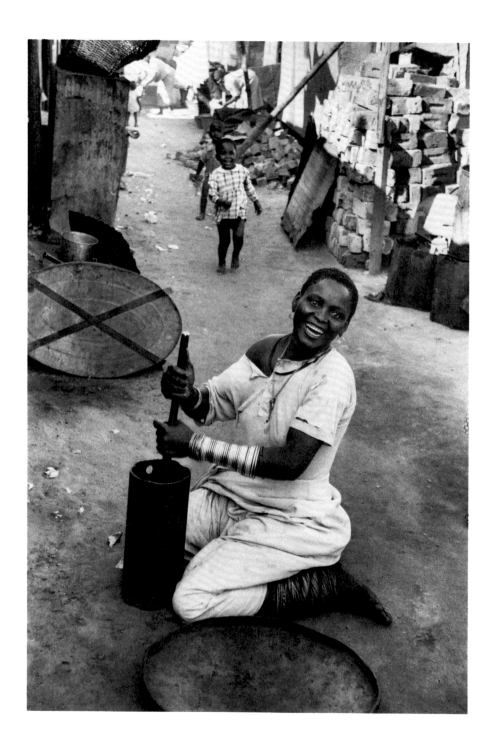

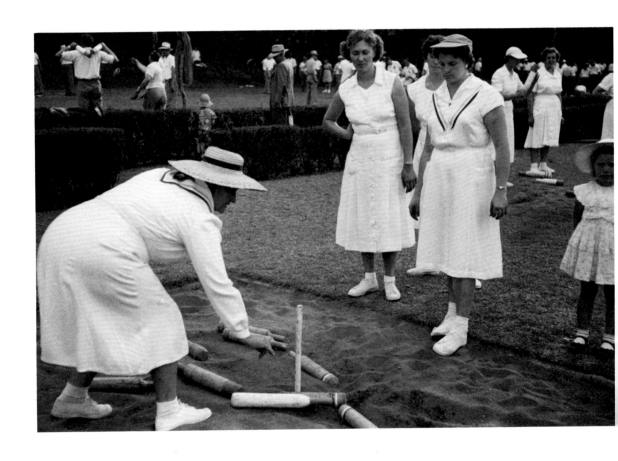

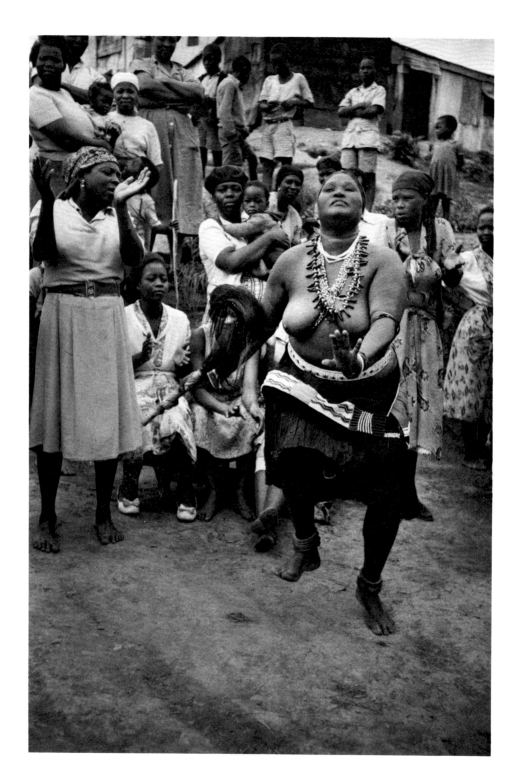

I was in the Soviet Union last winter during the gloomy months at the time of Hungary, Suez, and the bloodless revolt in Poland. I was there just a brief enough time to be regarded as an expert—two months. If you stay any longer, you get confused.

On visiting plants, installations, or collective farms you collect quite an entourage: interpreter, driver, local guide, often the factory director himself or the chief engineer, and usually an aide. Often there was a fellow whom they did not introduce; I took him to be "plant security." This can present some photographic problems. For example, on visiting a collective farm near Kiev, I asked to see the home of one of the collective farmers. With the very warmest display of hospitality, I was ushered into a small living room with my entire entourage following. Can you imagine trying to photograph unobtrusively in a room packed to overflowing?

I arranged to meet several Russian photographers. I had taken some photographs with me and I asked to see some of their work. They have been very impressed with photographs they have seen in our publications. I had seen work of a very high level in their publications, but what they brought to show me would have been acceptable in our most conservative salon exhibits. One chap even had some bromide prints. I was somewhat dismayed.

I discovered that they were making a demarcation between art photography and photography for publication. They asked me if we did not have art photographs. I said that we simply categorized photographs as either good or bad. They said that under a capitalist system it was necessary to photograph the struggles and problems in society, while under socialism it was necessary to photograph the future. I observed that it would not be un-Russian to photograph the struggles and realities of present-day Soviet Union.

I loved the Russian people. They are very shy about being photographed in their home, but after a bottle of vodka or so we all relaxed and I produced some good photographs. However, this kind of hospitality can become very wearing on the American constitution. It is most advisable, then, to practice photographing with the camera in one hand and balancing a glass of vodka in the other.

Another subject I find which has been done well in text and avoided in photographs is Eastern Europe. Traveling through these countries for *Fortune*, I did a story on religion in Roumania.

It seems that about five hundred years ago, when King Stephen the Great was fighting the Turks, he would have a church built every time he won a battle. So the countryside of Moldavia is dotted with

A Camera and a Glass of Vodka

Dan Weiner

churches and monasteries. I heard about this region while I was in Bucharest and went up to investigate.

I found a unique situation where a medieval society is still existing in a communist state. There has been a great accommodation between church and state there. For example in the Agappia Convent, the nuns are paid by the state to produce beautiful handiwork, such as pottery and rugs, which is in turn exported by the state.

I asked them how they were surviving under their new government. The Mother Superior quickly answered, "But my son—Christ was the first Communist."

Soviet Union and Eastern Europe

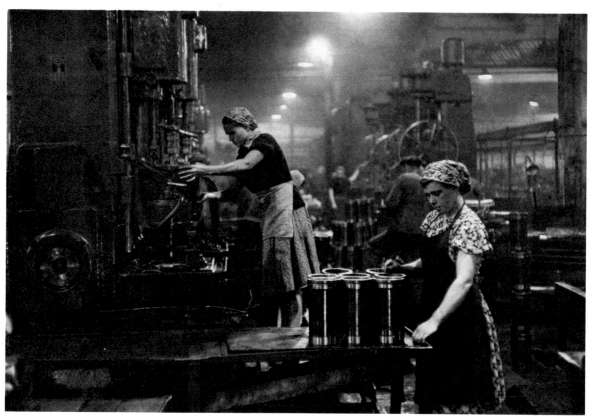

**Kharkov tractor plant,
USSR, 1957**

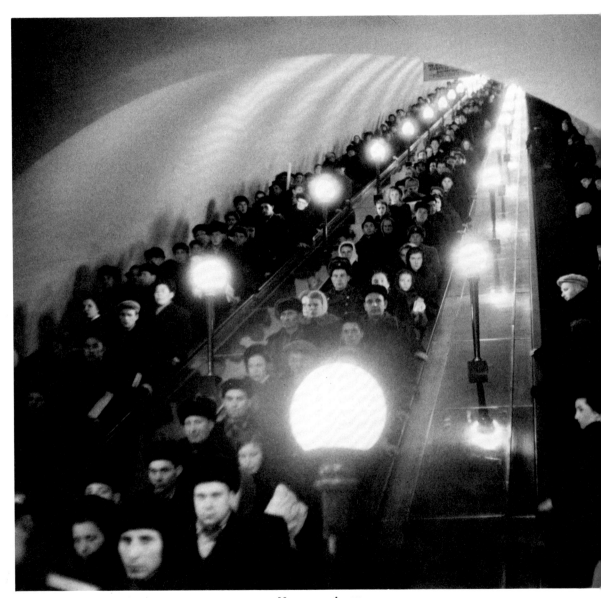

Moscow subway

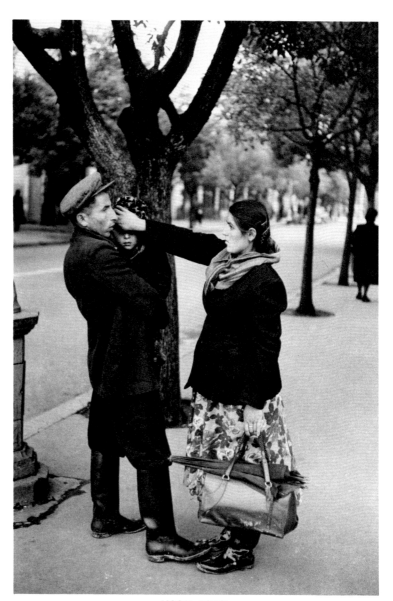

USSR, 1957

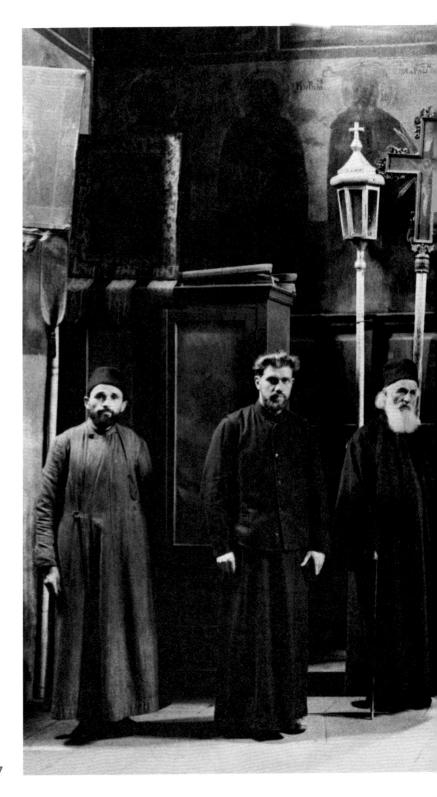

Roumania, 1957

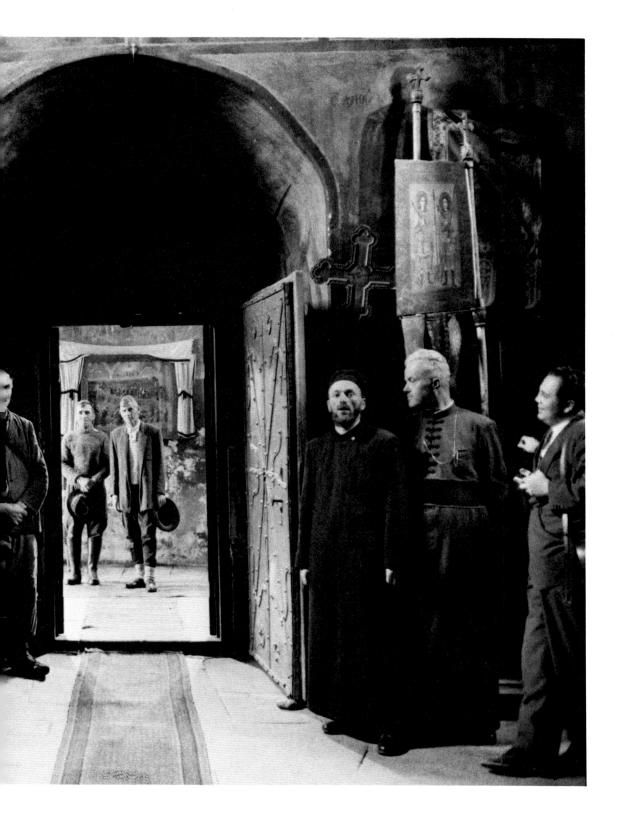

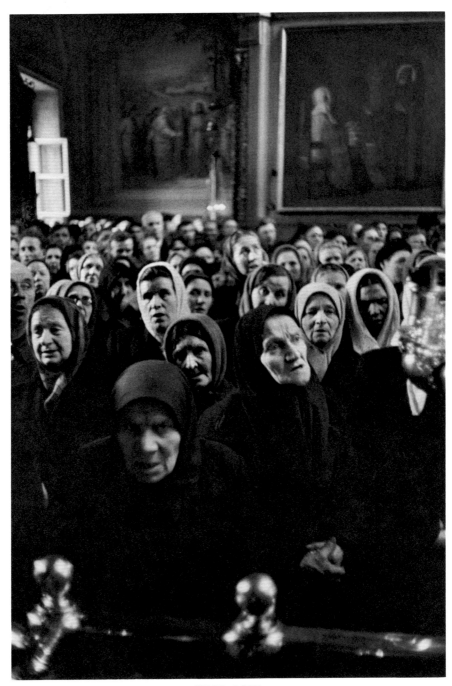

USSR, 1957

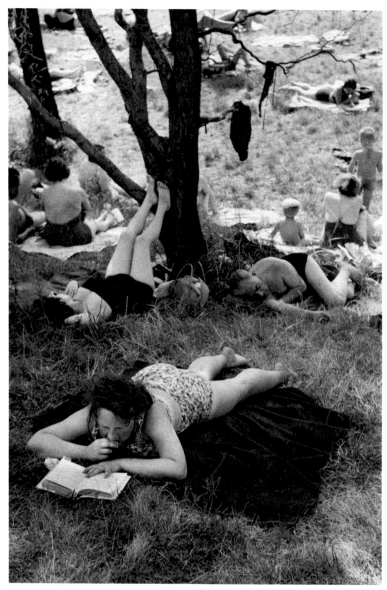

Sunbathers,
Czechoslovakia, 1957

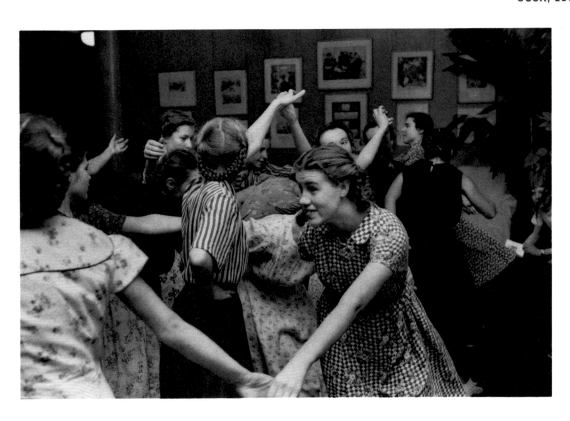

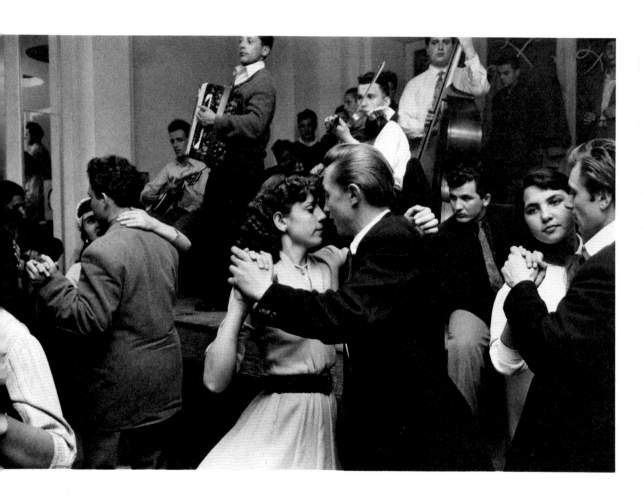

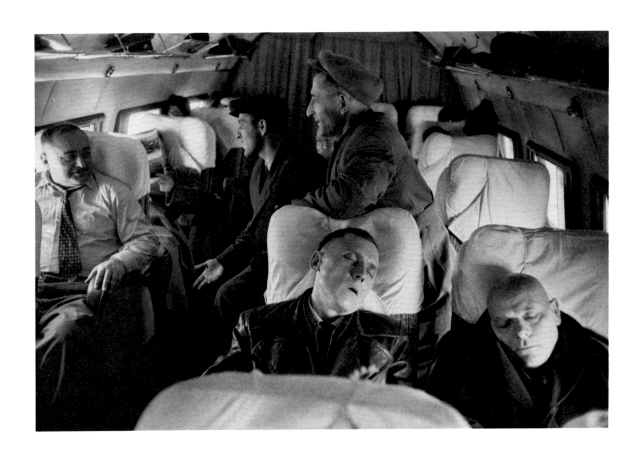

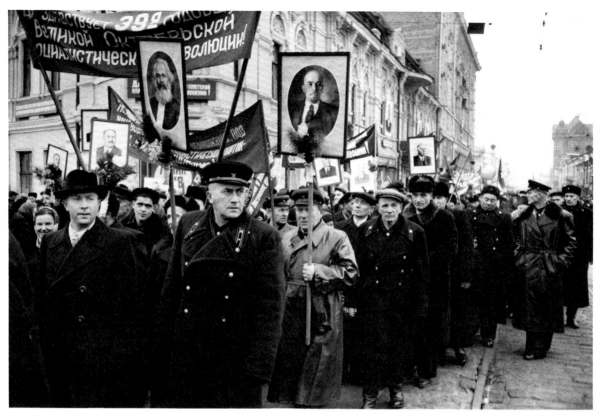

USSR, 1957

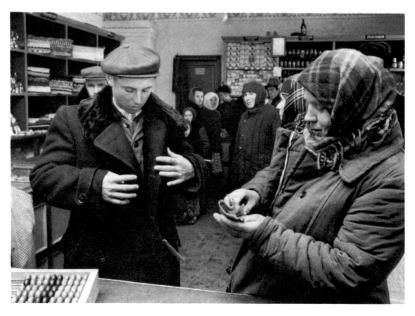

Nova Scotia

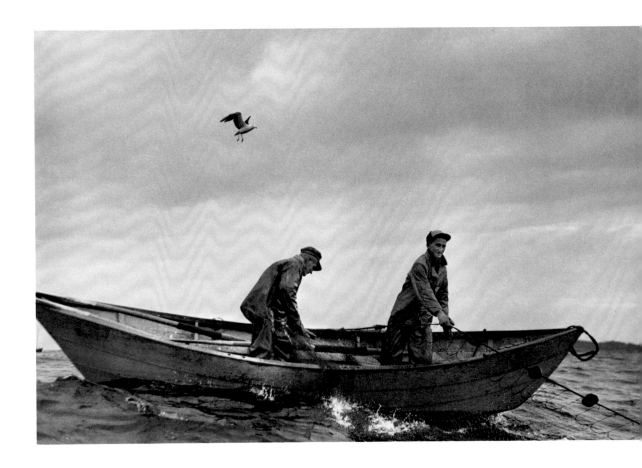

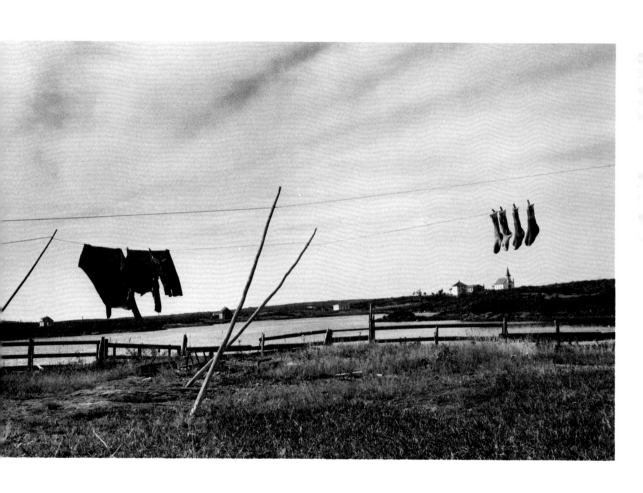

Nova Scotia, 1950

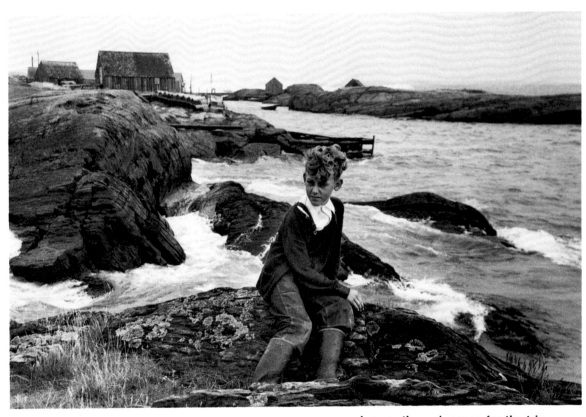

I guess the real reason for the trip
was to get away from my agent. I had been doing
a lot of assignments and needed a change of
pace, so my wife and I packed some camera
equipment into our car and away we went. We
chose Nova Scotia because we had never been
there before and it was not far from New York.

If by vacation you mean
a lot of rest and entertainment, then I suppose
this trip doesn't qualify.—I shot pictures almost
every day and probably worked harder than if
I had been on assignment. But it was fun and
exciting to explore an entirely new place.

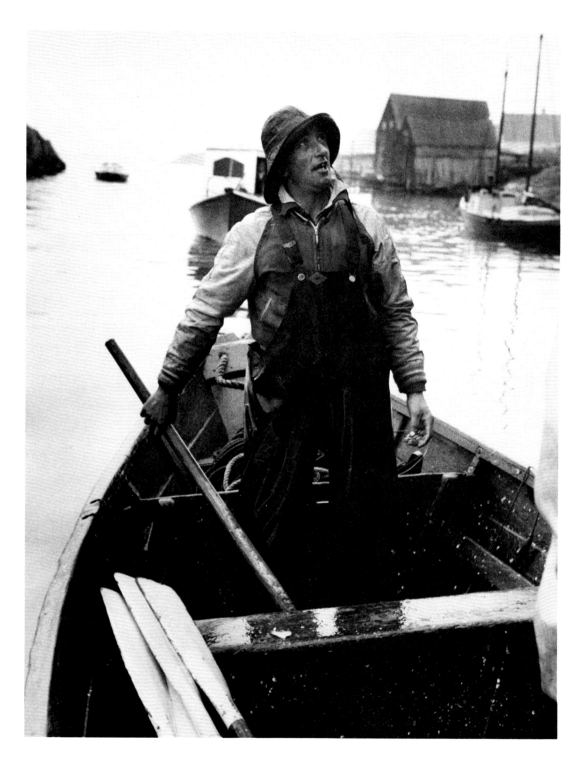

It is now fourteen years since Dan's untimely death in a plane crash. Time has not made it easier to write about my husband. But Dan was more than that—he was my teacher, my friend, the man with whom I worked and struggled. I can still hear him yell as he dashed out on an assignment, "Why don't you get off your ass and take that camera and make some pictures." I would smile sweetly and answer, "Soon, soon." It was simpler to stay home and bake a cake; it seemed enough to be married to a recognized photojournalist.

We had met in New York City in 1940. I was working in a bookshop with one of Dan's old school friends. Both of them were seriously working at painting and sharing a loft on East 10th Street. Dan made deliveries for a printing firm and would often drop by during the day. By his third visit I found myself very attracted to this young man, only to learn that he was spoken for. I also learned that he was short of money and was doing photographic portraits on the side in order to buy art supplies. I invested a week's earnings on a portrait so that I could be alone with this man at close range. The portrait was not successful but Dan and I fell in love. About a year and a half later, we married.

Dan was a native New Yorker, born Columbus Day, 1919. In his youth his family shared a brownstone with his grandparents on East 104th Street. Now Harlem, the area was then middle-class and mostly white, largely inhabited by immigrants who had moved uptown from the Lower East Side. Dan's father had great difficulty making ends meet. He floundered from job to job, business to business, and during the years of the depression found it difficult to support his family. Certainly for him America was not the golden land of opportunity. His own lack of security convinced him that each of his sons must learn a trade. Dan, however, was determined to paint, and this was cause for much ill feeling between father and son.

Dan's interest in photography began when he was fifteen; his uncle presented him with a Voigtlander 9 x 12cm camera for his birthday. At about eighteen, shortly after finishing high school, Dan had a heated confrontation with his father about his decision to paint. As a result he left home to live on his own. His mother remained sympathetic and helped him through the Art Students League and Pratt Institute. He supported himself by working during the day. Throughout this period he continued to photograph—mostly people of the city and Central Park in its varied seasons. It was shortly after we married that he decided to devote his attention entirely to photography. It was difficult for him to put the years of painting aside, but he found himself more adept and more comfortable as a photographer.

Personal Recollections

Sandra Weiner

I sometimes wonder what kind of photographer Dan would have been had he not been born and raised in a place like New York. There was no part of the city he did not know, yet it was a source of endless discovery. He would often return from photographing quite delirious with some new revelation.

His first photographic job was with Valentino Sarra, a highly successful commercial photographer, and it was with him that Dan undoubtedly acquired much of his darkroom skill, although, essentially, he was self-taught. It was during this period that we came upon the Photo League, an organization of young photographers dedicated to documenting their times. One of the other common denominators to be found among Photo League members was the fact that many of them, like Dan, were first-generation Americans. It is not surprising, therefore, that documentary photographers such as Lewis W. Hine, who photographed the immigrants pouring into America at the turn of the century and later followed them into the mines and sweat shops, and Jacob Riis, who portrayed the slums, should have made a deep impression on Dan, whose own parents came from Russia and Roumania in the early 1900s. Growing up in the years of the depression, Dan found the tragic vision of the early documentary movement—Lange, Evans, Shahn, and others in the Farm Security Administration—a strong influence. At the Photo League Dan was also introduced to the work of Adams, Weston, Strand, Abbott, Bresson, and Brassai. It was an inspiring period for a young photographer.

Sandra and Dan Weiner, 1942
by Valentino Sarra

For a number of years Dan taught at the Photo League School, and it was here that I developed my photographic skill. I remember taking a class with Paul Strand, the only such teaching he had ever done.

In 1942 Dan was drafted into the Air Force. He served four years as a photographer and instructor. I was able to live with him in south Georgia for three of these four army years. It was here that he bought an old Contax from an army friend and took to 35mm as if he had been using an eye-level camera all his life.

In 1947 the Photo League went out of existence. The Attorney General of the United States, with the help of Senator Joe McCarthy of Wisconsin, issued a list of "subversive organizations." The Photo League was on that list.

By now Dan was fully involved with photojournalism. He had made a stab at commercial photography right after the war but felt totally unsuited. Photojournalism was then rapidly reaching the high point of its development and was practiced principally in magazines.

Collier's, Fortune, and, of course, *Life* had both the space to devote to extended photographic stories and editors who were knowledgeable and enthusiastic about this form of expression. For Dan it marked a wonderful opportunity. The subject matter was often that about which he felt strongly, and the photo essay allowed him to go beyond supplying visual information to develop a dramatic concept out of the realities of a situation. Rarely have the terms "journalist" and "photographer" been so integrated in one man. For several years Dan traveled extensively. There were instances when he would go off on his own to do stories he felt should be seen—a farmer destroyed by a flood, the problems of aging and living in an old-age home, a fishing village in Nova Scotia where the same family had been living for one hundred years.

Our apartment in New York City in those years was on the fifth floor of a renovated tenement. The rent was low and since the bedroom was the longest room it became the darkroom as well. It seemed also the birthplace for our cats and we often accommodated a dozen kittens at a time. Dan had lived surrounded by cats all his life and could not stand to part with any. I was in my ninth month of pregnancy with our daughter, Dore, and space was at a premium.

The life of a photojournalist working with his wife as assistant is both exciting and impossible. After Dan would finish shooting a job he would rush home and we worked 'round the clock in the darkroom processing. We often found ourselves sleeping in shifts so as to deliver the job the following morning. Dan would be up all night printing and I would get up at five to wash, trim, and spot the prints while he slept until delivery time.

Dore was born in February 1951 and quickly adjusted to our way of life. By now Dan had established himself as a photojournalist. Our concession to change was to move to a building with an elevator and to farm out much of the darkroom work. Between jobs, when we were not panicked by the silence of the telephone, we would walk in the park with our little girl, go to museums, take pictures, see friends, bake cookies.

In 1954, after we had all spent four months touring and working in Europe, Dan went to South Africa at the invitation of Alan Paton. Having done a story with him on the Negro in America, Paton now wanted Dan to collaborate on a book about his own country—a country he loved yet found so tortuous to accept politically. The book, *South Africa in Transition,* was probably the first opportunity of seeing what has since become one of the great unresolved human tragedies of our generation: apartheid.

Dan Weiner and daughter, Dore, 1956
by Sandra Weiner

In the winter of 1956 Dan went to Russia for *Fortune*. The idea of photographing Russia was his own and he was able to stay for two months, gathering enough material for what he hoped would be the basis for another book. In the spring of 1957, again for *Fortune*, Dan went to Roumania, Czechoslovakia, and Poland. Dan's job was to get as comprehensive a look at the people, how they lived, and their industry as was possible. The photography was done with no specific preconception, but rather from a good deal of reading about the countries beforehand. These stories are a fine example of dealing with a large country in a limited time under many photographic restrictions.

These long absences did not sit so well with us at home, but slowly I came to understand that there was no alternative to Dan's way of life. Photographing his own city of New York was second nature to Dan, but coming into a strange new country and discovering it through his lens was perhaps even more exhilarating. His return meant marvelous weeks of reliving experiences, and I was quick to absorb his excitement and perceptions. Between his pictures and his words, it was as if I, too, had been there.

Since the death of Dan Weiner, photographer-author Sandra Weiner has published three books: *It's Wings that Make Birds Fly*, *Small Hands, Big Hands*, and *They Call Me Jack*. Her work reflects the curiosity and deep concern for human beings that was the essence of her husband's work. She teaches photography both at New York University and privately.

He had a remarkably sympathetic and inquisitive
eye that instinctively understood humanity, its pleasures, its
humor, and its tragedies. He was amused by its contradic-
tions and inanities and ironies, but always, it seemed to me,
without acrimony. He had a great sense of the dignity of life.
All this was in his pictures.

From a letter from Russell Lynes to Sandra Weiner.

CHRONOLOGY

1919
Born on October 12 in New York City.

1934
Received his first camera, a Voigtlander.

1937-1938
After attending New York City public schools, studied painting at the Art Students League.

1939-1940
To further his career in painting attended Pratt Institute. Joined the Photo League and came under the influence of Paul Strand, Dorothea Lange, Walker Evans, and many others.

1940-1942
Turned entirely to photography and went to work as an assistant to a commercial photographer.

1942-1946
Served in the Air Force as a photographer and instructor.

1946
Opened his own commercial studio in New York; photographed women's hats for catalogues.

1949
Gave up his studio and devoted himself full time to photojournalism, his work appearing in various magazines.

1953
Had his first one-man show at the Camera Club of New York. It subsequently traveled around the United States, including the Eastman House, Rochester, New York.

1954
Traveled in Europe and photographed.

1955
Traveled through South Africa with Alan Paton.

1956
South Africa in Transition, the result of his collaboration with Alan Paton, published by Charles Scribner's Sons.

1956
Covered the Mongomery, Alabama, bus boycott for *Collier's*, one of the first major stories published on the rising militancy of the civil rights movement.

1956-1957
Traveled extensively through Russia and Eastern Europe, much of his work being published by *Fortune*.

1959
Killed in a plane crash while on assignment near Versailles, Kentucky, January 26.

ARTICLES/PHOTOGRAPHS

1953
Portfolio, *Leica Magazine*, vol. VI, 3:4

U. S. Camera, Winter

1955
Family of Man (New York: Simon and Schuster)

1957
"Communion in Matera" portfolio, *ASMP Annual* (New York: Ridge Press/Pocket Books, Inc.)

1959
"Dan Weiner," by Arthur Miller, *Infinity*, vol. VIII:5 (May)

"The Photojournalist: A discussion between Dan Weiner and W. Eugene Smith," *Infinity*, vol. VIII:5 (May)

"Dan Weiner," by Walker Evans, *Print*, vol. XIII: 2 (March-April)

"Soviet Women" portfolio, *ASMP Annual* (New York: Ridge Press/Pocket Books, Inc.)

1960
"A Tribute to Dan Weiner," by Arthur Goldsmith, *Popular Photography Annual*, Tenth Anniversary Issue

1967
"Dan Weiner: Portfolio from *The Concerned Photographer*," *Infinity*, vol. XVI:10 (October)

1950-1959
Also published extensively in *Collier's*, *Fortune*, and *Harper's Bazaar*

BOOKS

South Africa in Transition, text by Alan Paton (New York: Charles Scribner's Sons, 1956)

The Concerned Photographer, New York: Grossman Publishers, 1968

EXHIBITIONS

1953
One-man show, Camera Club of New York

1954
Eastman House, Rochester, New York, and University of Indiana, Bloomington, Indiana

1955
"Photographs of Italy," Limelight Gallery, New York

1967
"The Concerned Photographer" Organized by the International Fund for Concerned Photography, Inc., (one of six one-man shows), Riverside Museum, New York

1968-69
Tokyo and other principal cities of Japan

1969
The Smithsonian Institution, Washington, D.C.

1969-72
Circulated in United States by the Smithsonian Institution Traveling Exhibition Service and the International Fund for Concerned Photography, Inc.

1969—
Circulating in Italy, Israel, Switzerland, England and Czechoslovakia under the auspices of the International Fund for Concerned Photography, Inc.